Visual

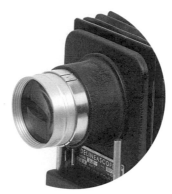

Pedagogy at

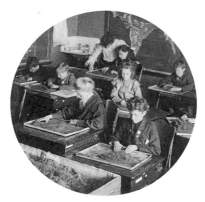

The University

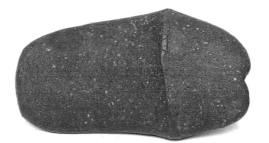

of Chicago

Looking to Learn

Visual Pedagogy

at The University

of Chicago

LINDA SEIDEL AND KATHERINE TAYLOR

The David and Alfred Smart Museum of Art
The University of Chicago

Catalogue of an exhibition at
The David and Alfred Smart Museum of Art,
The University of Chicago
7 May—9 June 1996

·

The research, exhibition, and catalogue for *Looking to Learn:
Visual Pedagogy at The University of Chicago* were funded in part
by a multiple-year grant from the Andrew W. Mellon Foundation
to the Smart Museum to encourage interdisciplinary use of its
collections by University of Chicago faculty and students both in
courses and through the format of the special exhibition.

A portion of the Smart Museum's general operating funds for
the 1995—96 fiscal year was provided through a grant from the
Institute of Museums Services, a federal agency that offers
general operating support to the nation's museums, and a grant
from the Illinois Arts Council, a state agency.

Library of Congress Catalogue Card Number: 98-60521

ISBN: 0-935573-21-6

Photography credits:
Photography by Tom Van Eynde
(unless otherwise noted); Smart
Museum Archives: figs. 7, 10;
courtesy News Office, University
of Chicago: fig. 5; courtesy
Department of Special
Collections, University of
Chicago: figs. 4, 6, 8, 9, 12,
13, 18–20, 24, 25, 27–36, 39;
courtesy Yerkes Observatory,
University of Chicago: fig. 41

Editors: Richard A. Born
* and Liz Siegel*
Design: Joan Sommers Design
Printing: Meridian Printing

Contents

Preface and Acknowledgments

The Smart Museum is pleased to publish this catalogue documenting the exhibition *Looking to Learn: Visual Pedagogy at The University of Chicago*, and we are grateful to Professors Linda Seidel and Katherine Taylor, who conceived the idea for the project and brought it to a brilliant conclusion. We are also grateful to the students in their "Visual Pedagogy" course, who thoughtfully researched and articulated the issues of the project. Funded through a grant from the Andrew W. Mellon Foundation, which encourages innovative uses of the Museum's collections by faculty and students for courses and research projects, *Looking to Learn* is an especially thought-provoking Mellon project, for it brings under scrutiny the history of the University of Chicago's commitment to the visual arts and its engagement over a 100-year period with visual and object-based modes of teaching and learning.

As this exhibition and catalogue demonstrate, the history of the University's engagement with the visual arts has not been unproblematic. At the University's founding in 1893, President William Rainey Harper saw to it that two museums housing archaeological and ethnographic artifacts were among the first buildings constructed, so strongly did he feel that actual artifacts were necessary for teaching purposes. Later, in the 1920s, the University drew up plans for an Institute of Fine Arts, to house the Department of Art, and to legitimize and facilitate the study of art history and studio art. But the project was later canceled because of other priorities, and a more modest art complex, housing the department and the University's first art museum, was built only in 1974.

Reading this history, which is here situated in the larger context of the use of other kinds of visual materials in university teaching and research, leads me to reflect on the role of the university art museum in today's academic environment. It is fascinating to trace the ways in which "works of art," as opposed to artifacts, visual aids, or demonstration

objects, have been constructed over the years, and how they have been deployed to meet changing pedagogical needs and interests. Most recently, for example, works of art have all but lost their previously privileged status, subsumed under the rubric of "visual culture," which encompasses all modes of communication that rely on visual rather than text- or audio-based means to embody or relay meaning. Situated as they are within academic environments, university art museums have tried to keep abreast of these ever-evolving trends, while at the same time preserving and interpreting for an ever broadening audience what has been deemed worthy of collecting by past generations of university scholars and curators. For me, *Looking to Learn* demonstrates the difficulty of predicting how tomorrow's university museum users and audiences will view "works of art" and the various visual pedagogies they make possible. Interest in object-based scholarship will no doubt continue to wax and wane, but the university museum cannot stop making the best decisions it can about which objects should be preserved to teach again tomorrow, and which are less likely to be of use or interest in the future. Our colleagues in the Department of Art History, and other departments, continue to keep us guessing, and that is how it should be.

Many collectors, individuals, and University of Chicago departments have provided assistance in the planning, organization, and presentation of this exhibition and catalogue. In particular, we would like to thank John Butler-Ludwig, Curator of Visual Resources in the Department of Art History; Richard Bumstead, Department of Facilities Planning and Management; Karen Wilson, Director, John Larson, Museum Archivist, and Raymond Tindel, Registrar, The Oriental Institute Museum; Teresa Cosey, News Office; Heidi Cuesta-Cipriano and Alta Goodwine, Department of Sociology; Alice D. Schreyer, Curator, Valarie Brocato, Exhibitions and Conservation Supervisor, Debra Levine, Public Services Assistant, Daniel Meyer, Associate Curator and University Archivist, and Suzi Taraba, former Public Services Librarian, Special Collections, Joseph Regenstein Library; and Judith A. Bausch, Yerkes Observatory; as well as Catherine Bell, Ben Field, and Michael Field. At the Smart Museum, we wish to acknowledge Curator Richard Born, without whose diligent work and attention to detail the project could not have been realized, and Graduate Curatorial Interns Kris Ercums and Liz Siegel. We also thank Preparator Rudy Bernal and Registrar Martha Coomes-Sharma, in addition to volunteers Helen Halpern, Joseph P. Shure, and Agnes Zellner.

Finally we thank the Andrew W. Mellon Foundation, whose financial support made possible the class, exhibition, and catalogue, and especially Angelica Zander Rudenstine, the Foundation's Senior Advisor for Museums and Conservation.

Kimerly Rorschach
Director

FIG. 1
Installation of *Looking to Learn:*
Visual Pedagogy at The University
of Chicago at the Smart Museum:
"Museum or Library: Campus
Display Spaces and Disciplinary
Definitions"

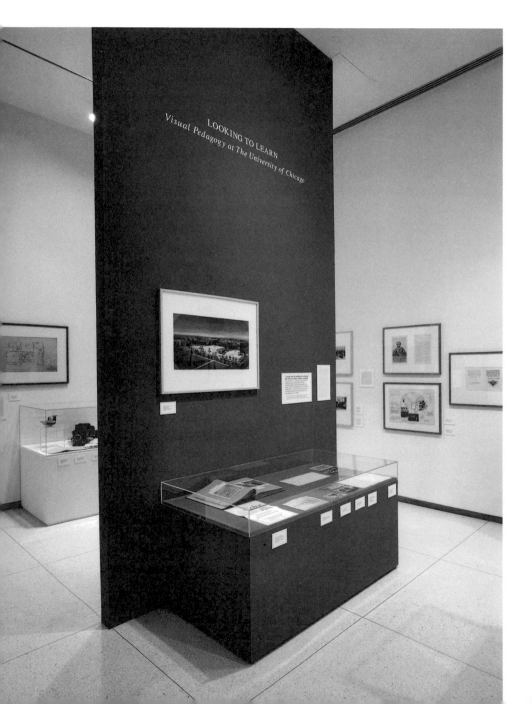

Introduction

LINDA SEIDEL AND KATHERINE TAYLOR

This exhibition grew out of a course taught in the Art History department at the University of Chicago during the fall of 1995. The course had as its premise the notion that academic learning, on this campus as elsewhere, has been shaped from the outset as much by the collection, utilization, and manipulation of visual materials as it has been by the acquisition and circulation of texts. Such diverse endeavors and strategies as the definition of disciplinary and departmental interests, the planning and arrangement of academic buildings, the design of social and athletic facilities for the shaping of non-curricular aspects of student life, and the participation of the University in civic and national endeavors all involve visual constructions of the University's sense of purpose and goals for diverse audiences and communities.

In preparation for this class, a graduate research assistant worked during the summer with one of the two faculty members responsible for the course, combing Special Collections and the University Archives, the Smart Museum, the Physical Plant files, and other campus resources in search of topics that students registered for the class might investigate. In the fall quarter, thirteen graduate and undergraduate students from a variety of University programs and departments worked in teams of two and three under the supervision of Professors Linda Seidel and Katherine Taylor and with the generous guidance of the Regenstein Library's Special Collections staff to develop a detailed proposal for an exhibition. A first set of sessions devoted to historical and critical readings on collecting and

exhibiting, and their social implications, across the spectrum of museum types, and a second set with guests discussing their work and skills—oral history techniques, ethnographic inquiry, imaging techniques in the sciences, and preservation and display traditions and parameters—primed project members for a plunge into University basements. The students then located and proposed an array of objects that would exemplify the underlying premise of the class, determined the inter-related themes around which component displays would be organized, and drafted explanatory texts for the installation. Their presentation of the exhibition to a professional jury from the Renaissance Society, the Smart Museum, and Special Collections further integrated the plan and brought the course to a close.

The title chosen for the exhibition playfully inverts the name of the celebrated textbook written two generations earlier for the University's introductory art course. Joshua Taylor's *Learning to Look* (1957), still in print and in use, teaches the student how to analyze isolated works of painting, sculpture, and drawing on display in museums. The exhibition *Looking to Learn* challenged such a decontextualized approach to images and to learning by setting ritual, functional, and intentionally aesthetic objects side by side, together with inventories, technical viewing devices, photographs of ceremonial practices deploying the objects, printed materials representing them, and records and fragments of some of the environments to which they have belonged (figs. 1, 2). It sought to enlist the visitor in a wide-ranging consideration of issues of representation

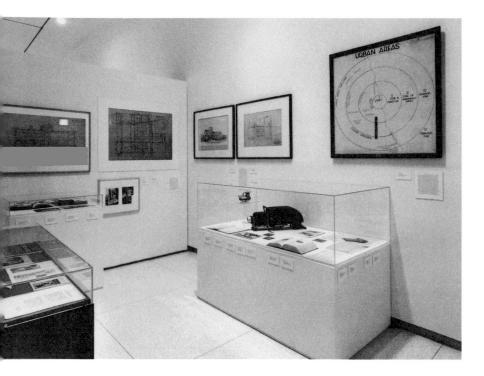

FIG. 2

Installation of *Looking to Learn: Visual Pedagogy at The University of Chicago* at the Smart Museum: "Disciplining Study in Art and Science" (right) and "Disciplining the Body: Physical Culture and Model Behavior" (left)

that encompassed but exceeded the aesthetic. In so doing, it broadened the existing critiques of exhibition practice focused on the museum (to take but two instances, *Exhibiting Cultures: The Poetics and Politics of Museum Display*, eds. Ivan Karp and Steven Lavine [Washington, D.C.: Smithsonian Institution Press, 1991] and Susan Vogel's 1988 exhibition, *Art/Artifact*, at the Center for African Art in New York) in order to consider how university folk engage with the visual world in constructing scholarly expertise. A grant from the Andrew W. Mellon Foundation's program to enhance the Smart Museum's involvement in the University curriculum supported the planning and mounting of the exhibition, which was on view at the Smart Museum from 7 May to 9 June 1996.

At the conclusion of the course in December 1995, Special Collections, which had been so closely involved in the planning of the Smart Museum exhibit, asked participants in the class to consider expanding the project to include an installation in

FIG. 3
Installation of
*Looking to Learn:
Visual Pedagogy at The
University of Chicago*
at the Smart Museum:
"Constructing a Public
Image: The University of
Chicago and the World's
Fair"

the Library. The portion of the project that seemed particularly suitable for that venue focused on the contributions of specific research collections in the Library to the University's array of visual resources. Students expanded work on two bodies of material, one for the Smart exhibition and the other for Regenstein Library, selecting additional objects from the earliest and most recent major acquisitions to the Library for display in Special Collections (7 May–14 October 1996).

These linked installations probed a selection of ways in which objects, artifacts, and images have been collected, deployed, and exhibited in teaching, research, and self-representation from the earliest days of the University. Individual displays demonstrated the complementary ways in which visual and textual representations contribute to and construct knowledge; others documented, with the help of vintage photographs, how visual material was used to model the minds and bodies of students from the Lab School through the College. One vitrine recounted the high-sci image the University projected in the Chicago World's Fair of 1933 through a manipulation of innovative technology. The illumination of an exhibition hall on opening night by means of energy harnessed from a star was as visually arresting and up-to-date then as the videos of the most recent planetary landing are today (fig. 3).

The installations demonstrated and dramatized the chief premise of the course: the centrality of visual representations in all areas of pedagogical practices, not only in the arenas that have been separately designed as venues for fine art display.

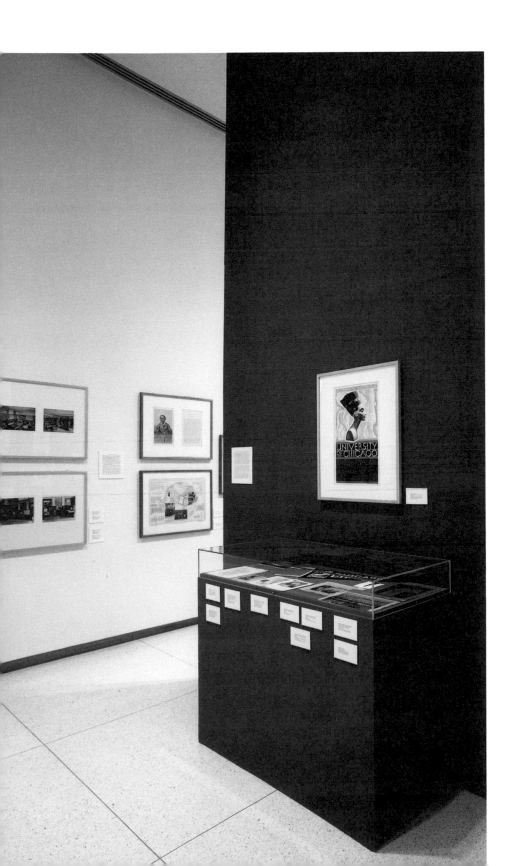

Linking the two exhibition sites and extending the show across campus was a take-away guide which a student had prepared to enable visitors to locate the original buildings from which materials on display had come and inspect the remaining traces of the environments in which these objects had originally been displayed and deployed (see pages 54–55).

This exhibition was organized by: Andrew Auten, Catherine Bell, Clive de Freitas, Jeff Good, Krishna Knabe, Aden Kumler, Margaret Laster, Siobhan McDevitt, Alexandra Onuf, Linda Seidel, Mari Shopsis, Helene Sroat, Katherine Taylor, Dena van der Wal, Corinne Wise, and Helene Yentis, with the generous assistance of Richard Born and Suzy Taraba of the Smart Museum and Special Collections, respectively.

LINDA SEIDEL AND KATHERINE TAYLOR

Looking to
Learn: Visual
Pedagogy at
The University
of Chicago

*Museum or Library: Campus Display Spaces
and Disciplinary Definitions*

Two teaching museums were included in architect
Henry Ives Cobb's original master plan for the
University of Chicago campus on the south side of
the city, in close proximity to the site of the 1893
World's Columbian Exposition. The museums—the
Walker Museum for natural history, especially pale-
ontology (1893), and the Haskell Oriental Museum
for religious artifacts from the ancient Near East
(1896)—count among the very first buildings to be
constructed. Designed in a free Gothic idiom
deemed visually appropriate to the values of a teach-
ing and research institution, the buildings and their
prominent positions in the University's plan testi-
fy to the importance the University founders placed
on visual displays and their pedagogical value (cat.
nos. 1, 2; figs. 4, 5). The University, opened in the
shadow of the Columbian Exposition, hoped to
acquire exhibits from the fair to launch its own col-
lecting, and considered that objects and artifacts
required the dedicated housing that somehow books
could at least temporarily forgo. University President
William Rainey Harper, in his comments at the cor-
nerstone ceremony of Haskell, stressed that the
establishment of a museum was a higher priority for
the new University than the construction of a library
(cat. no. 3; fig. 6).

Reading rooms were simply threaded through
departmental buildings with an almost-immediate-
ly inadequate hub at Harper Memorial Library
(1912). Only in 1970 was the centralized Regenstein

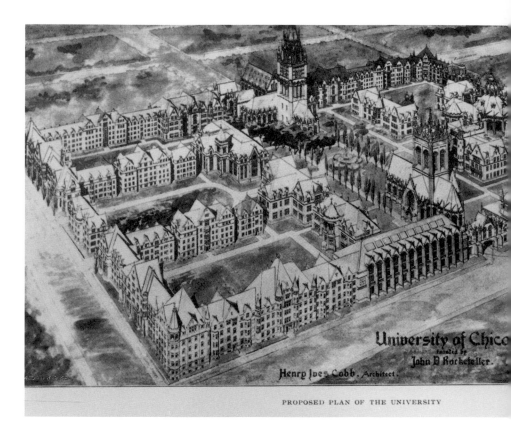

PROPOSED PLAN OF THE UNIVERSITY

Library opened, north of Cobb's quadrangular campus, with a department of Special Collections to house those books and related collections whose artifactual significance renders them, like museum collections, too precious to place in the circulating stacks. This material was exemplified in the exhibition by prints and ephemera from the Berlin and Rosenberger Collections (see cat. nos. 11–14, 19–22; figs. 11–13, 18–20).

The David and Alfred Smart Museum of Art, housed together with the Department of Art History in the Cochrane-Woods Art Center and originally intended to expand into a building complex for the visual and performing arts, was opened north of Regenstein just four years after the Library, further expanding the boundaries of the campus (cat. nos. 7, 8; fig. 7). The first museum building dedicated

FIG. 4

General Campus View of Henry Ives Cobb Plan of 1893 (cat. no. 1)

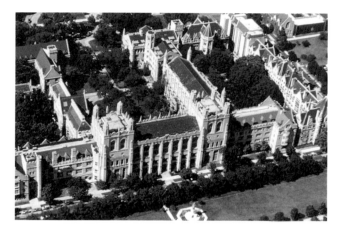

FIG. 5

Recent aerial view
of the campus of the
University of Chicago
(cat. no. 2)

FIG. 6

Handwritten notes for President
Harper's statement at the cornerstone
ceremony of Haskell Oriental
Museum, 1893 (cat. no. 3)

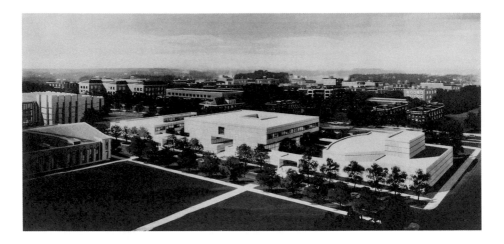

FIG. 7.
Edward Larrabee
Barnes, *Proposal for
Arts Center at 55th
Street and Greenwood
Avenue*, 1972
(cat. no. 7)

to fine art at the University, the Smart was nonetheless defined by the faculty as a teaching and research facility, and inherited a number of collections originally housed at earlier discipline-specific museums, particularly Walker and Haskell (cat. nos. 4, 6; figs. 8, 9). One of these, the Buckley Collection of Shinto Objects, collected in Japan and given to the University by Edmund Buckley, an adjunct professor of Comparative Religions, was first displayed in the Walker Museum in 1894 and then moved to the more appropriate quarters of the Haskell Oriental Museum after 1896. Originally assembled and used in teaching to explain the history of religion, these objects have traveled through the changing history of display techniques and from the disciplinary domains of natural and religious history into art history (see cat. nos. 25–32; figs. 16, 17). In their current home in the Smart Museum, they have assumed an additional valence as art works.

The Smart Museum and the Oriental Institute of 1931 are the University's present-day successors to the Walker and Haskell Museums; the latter have been pressed into service for other functions. As one of the first campus buildings, much of Walker's museum space was temporarily allocated to classrooms for related departments, including geology,

FIG. 8
Haskell Oriental Museum: Exhibition Gallery, 1898
(cat. no. 4)

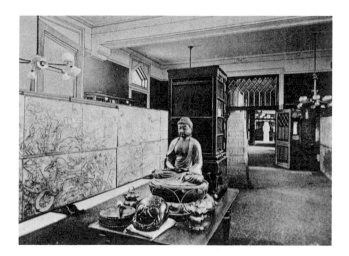

FIG. 9
Walker Museum: Exhibition Gallery
(cat. no. 6)

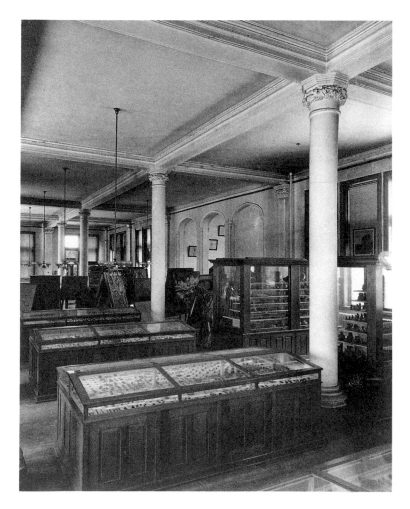

paleontology, geography, and anthropology. The donor, George Walker, president of the Chicago Academy of Sciences, joined with faculty led by the museum's celebrated director, the geologist Thomas Chamberlin, in pressing the University to restore the exhibition space and enlarge Walker into an all-purpose museum for the University, with smaller study museums to be housed in each department building (cat. no. 5). While seriously considered, this plan went unrealized. Instead, Walker's important paleontology collection went to the Field Museum in 1953, with the promise of special access to University members. Today, a renovated Walker houses part of the Business School, while the spectacular paleontological discoveries made by Professor Paul Sereno have found an occasional display space in the atrium of the Crerar Library for Science (opened in 1984). Bones transformed into artifacts, however, as in the Buckley and Creel collections presented here, now have a home in the Smart Museum (cat. nos. 17, 18, 30).

Haskell, established as a center for the study of the "oriental" roots of Judaism and Christianity, functioned both as a research and teaching collection joined to department offices and as a public museum; its directors included no less than President Harper himself, who governed the University from his Haskell office, and Egyptologist James Henry Breasted, who shifted the collections to his new Oriental Institute in 1931. The high ceilings of the Haskell Museum galleries can still be detected in the renovated building that now houses the Anthropology Department.

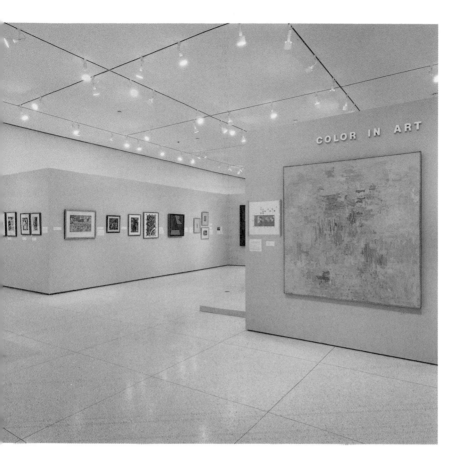

FIG. 10

Color in Art exhibition at the Smart Museum, 1975 (cat. no. 9b)

Characteristics of gallery design and display techniques differentiate the densely-packed exhibits in Walker and Haskell from the Smart Museum's second exhibition, *Color in Art* (cat. no. 9; fig. 10), documenting changing attitudes toward art, artifacts, and aesthetics. In this installation, the pristine white and pale gray volumes of the museum, sparsely hung, lent a scientific ambiance to analyses of color in painting through technical terminology and analytic tools; the spirit and values of the textbook *Learning to Look* permeated the show. One of the challenges the Smart Museum now embraces is how visually to resituate the artifacts it displays, not only in formal but also in cultural and historical contexts, along the lines that scholarship, by art historians and others across campus, has insistently and

successfully pursued for the past quarter century. In this sense, the Smart Museum, initially in service to a wide range of disciplines, now looks to learn critically from them, without foregoing the visual acuity it was founded to promote.

Institutional, Disciplinary, and Private Collecting

Collections of diverse materials, including images and objects as well as texts, have formed the basis for the University's teaching and research enterprises since its earliest days. Even before attention was paid to a library building, announcement was made by the Board of Trustees of the purchase of the Berlin Collection of prints, books, letters, and manuscripts from a German bookseller, Calvary and Company. A news item about this major institutional acquisition appeared on the front page of the *New York Times* for 28 October 1891, emphasizing its size, diversity, and potential value for academic scholarship in a wide range of disciplines (cat. no. 10; fig. 11). President Harper hoped that this major institutional acquisition would establish the University of Chicago as one of the finest research facilities in the country. The variety of materials contained in the Berlin Collection bears out Harper's observation that the University's need for a museum, conceived traditionally as a building for

FIG. 11
A Valuable Library Bought (cat. no. 10)

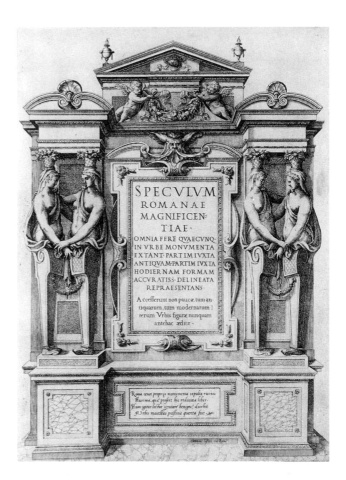

the accumulation and display of historical, scientific, and artistic works, preceded that of a library, understood simply as a repository for printed materials.

Among the treasures included in the Berlin Collection was the *Speculum Romanae Magnificentiae*, a group of 994 etchings and engravings produced for tourists to Rome between the sixteenth and eighteenth centuries (cat. nos. 11–14). The collection of prints of the city of Rome appears to have been a haphazard pastime until the middle of the sixteenth century when Antonio Lafreri, an important local publisher, formalized the activity with the production of an elegant title page for the collectors' albums (fig. 12). The tradition continued through several generations, during which Lafreri and his successors published several editions of prints in which a wide range of architectural and artistic sub-

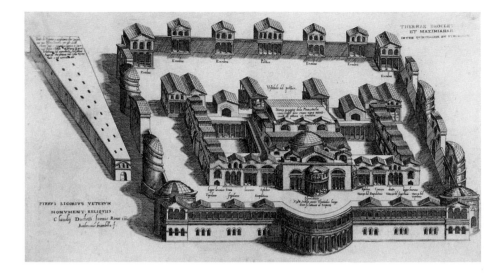

jects were depicted. These included detailed maps and nostalgic views of the city, copies of paintings and architectural ornament that were still visible in spite of the ruinous condition of many of the monuments, and elevations and annotated plans of ancient structures as they once would have appeared. The University's set of these prints is one of the most complete in existence.

The print of Diocletian's Baths, one of several of this subject in the *Speculum Romanae*, presents the viewer with the notion of how these vast vaulted structures would have looked when they were built late in the third century C.E. (cat. no. 12; fig. 13). In the foreground, differentiated chambers for hot, warm, and cold baths are featured; each is distinctly labeled in the way that the showerheads in Bartlett Gymnasium and the changing rooms in Ida Noyes Hall are emphatically specified in plans of those campus buildings (see cat. nos. 58, 62; fig. 34). While numerous other prints in the series relate to types of campus structures such as theaters and

FIG. 13
Italian, after
Ambrogio Brambilla,
*Thermae Diocletianae
et Maximianae
inter Quirinalem et
Viminalem* (cat. no. 12)

FIG. 14
Chinese (Shang
dynasty), *Knife*,
13th–12th century
B.C.E. (cat. no. 16)

sporting arenas, the main interest of the prints from the perspective of this project is in the varied modes of representation that are simultaneously explored; these range from map, plan, and diagram to descriptive view, romantic remembrance, and fantastic reconstruction.

In contrast to this body of material, which documents vast historic areas of inquiry from antiquity through the nineteenth century, the collection of Chinese ritual and domestic objects such as oracle bones and hairpins (cat. nos. 17, 18) dates to the 150 years of the late Shang dynasty, circa 1200–1050 B.C.E. The objects were discovered during a period of intense archaeological activity at Anyang, the site of the last Shang capital that Professor Herrlee Creel visited on numerous occasions during his stay in China in the early 1930s. Creel and his wife originally amassed these items for use in his research and had them sent back to the United States in specially constructed boxes in which they have been preserved (cat. no. 16; fig. 14). Upon arrival in Chicago, the objects were employed by Professor Creel as visual aids in the classroom. He used the artifacts to teach students in the newly established department devoted to Chinese studies about the material reality of the distant and far-off past, especially in regard to inscription practices. These tiny

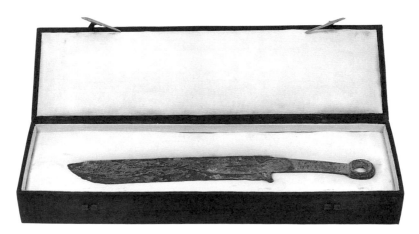

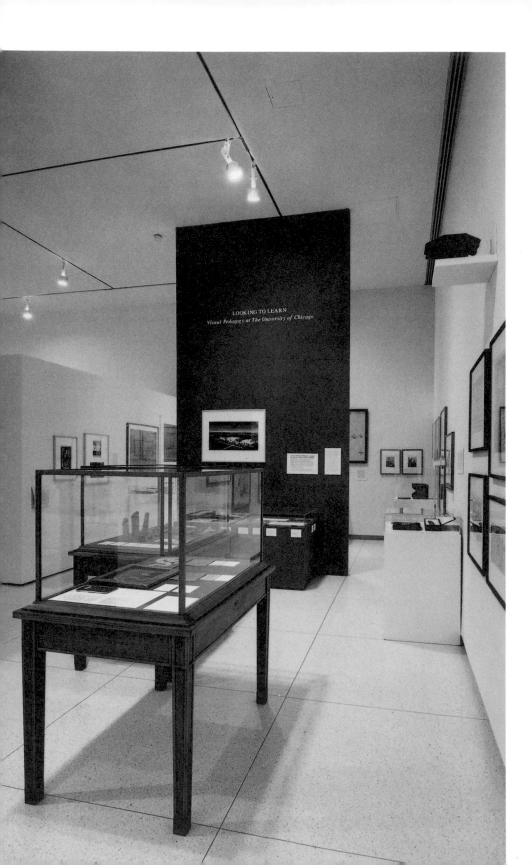

FIG. 15
Installation of
Looking to Learn:
Visual Pedagogy at
The University of
Chicago at the Smart
Museum: "Institutional,
Disciplinary, and
Private Collecting"

objects, startlingly rich in visual detail, were originally housed in Creel's office at the Oriental Institute; they now form part of the East Asian study collection at the Smart Museum.

The functional objects collected by Professor Creel in the 1930s resemble in many ways the Shinto ritual material that was assembled by Professor Buckley in Japan in the 1890s and initially installed in the Haskell Oriental Museum (cat. nos. 25–32). Their presentation for this exhibition in wood display cases originally made for the Haskell Museum's successor, the Oriental Institute Museum, differentiated between modes of display: two votive offering plaques were presented as aesthetic objects while a dense display of divining bones, phallic objects in wood, and stone and earthenware implements were amassed as though for ritual performance (fig. 15). The plaques were accompanied by copies of pages from the 1894 *Circular Regarding Collections of Religious Objects* by the Walker Museum's curator, which inventoried the collection in addition to explaining how to collect Shinto objects (cat. no. 23), and a handwritten notebook in which Haskell enumerated his acquisitions (cat. no. 24). The second case displayed objects according to the way in which they had been presented at the Haskell Museum, on low, uncovered tables (see fig. 8); in addition, documentary photographs of these objects' original Japanese contexts, carefully recorded by Professor Buckley in now-faded but invaluable images, prompted students to think about their initial sites and rites in Shinto worship (cat. nos. 27, 31; figs. 16, 17).

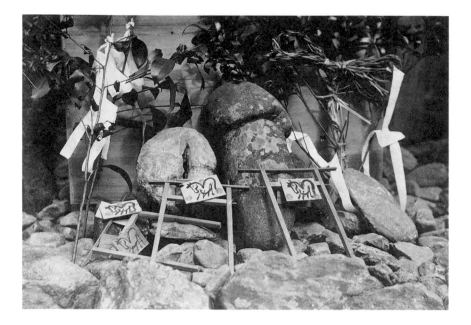

FIG. 16A–D
Photographers
unknown (Japanese,
Meiji period),
*Phallic Stones and
Straw Phallus Fertility
Symbols at Shrine Sites
in Japan*, late 19th
century (cat. no.
27a–d)

FIG. 17
Japanese (Edo or
Meiji period), *Three
Phallic Stones*,
18th or 19th century
(cat. no. 29a–c)

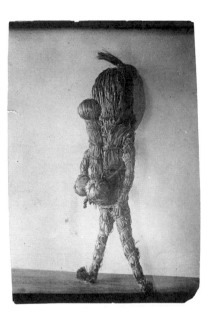

29

FIG. 18

The Turf Frauds, Harry Benson, 29 September 1877 (cat. no. 21)

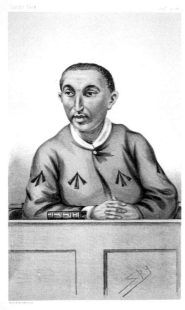

Private collections are compiled for more varied purposes than disciplinary ones and follow highly distinctive patterns. Ludwig Rosenberger's fascination with distinguished Jewish figures from the past, along with his attention to English material in particular, provides a rich array of resources for the study of Jews in history. His library of Judaica, acquired by the University in 1980, embraces a huge number of letters, books, prints, and broadsides, all of which emphasize the diversity of the private collector's taste.

An album of cartoon-like depictions of prominent, occasionally infamous Jews, which Rosenberger presented to his wife Irmgard, draws on the extensive series of images of interesting or outstanding

FIG. 19

Mr. Reuben Sassoon, from *Vanity Fair* (20 September 1890), lithograph, sheet: 14 7/8 x 10 1/8 (37.8 x 25.7), Special Collections, The University of Chicago Library, The Ludwig Rosenberger Library of Judaica. Included in the Rosenberger Collection case in the Special Collections *Looking to Learn Too* exhibition, 7 May–14 October 1996.

public figures that appeared in the late-nineteenth-century English magazine *Vanity Fair*. Sketches, such as one entitled *Turf Frauds*, were published every week in the journal as examples of celebrated individuals from all walks of life whose successful careers might serve as models of behavior (cat. no. 21; fig. 18). Harry Benson, "one of the most finished swindlers the world has ever known," according to the text accompanying the illustration, redeemed himself late in life through the donation of ill-gotten gain to charitable institutions. His tawny, sober image contrasts with the brilliantly colored, elegant silhouette of Reuben Sassoon, friend of King Edward VII and one of eight sons of the founder of the Anglo-Indian Sassoon dynasty, whose vast mercantile empire extended from England to Canton (fig. 19).

The body of Judaic and Hebraic printed materials in the Rosenberger Collection brings together information about various Jewish communities and individuals at different times in history. A beautifully printed sheet of Hebrew script from the eighteenth century recapitulates the set of statutes that had been drawn up in the previous century by Catholic authorities to regulate the size, distribution, and usage of the Jewish Community of Ferrara's

FIG. 20
F. Bonaventura, *Statutes Regulating the Jewish Community of Ferrara*, 1761 (cat. no. 20)

dwellings (cat. no. 20; fig. 20). Testimony regarding the accuracy of the text is provided in Italian, by a Church official, to the left.

The Collection includes nearly 20,000 volumes in the languages Rosenberger spoke fluently— English, French, and German—beginning with one of the earliest illustrated accounts of a voyage to the Holy Land. Bernhard von Breydenbach, Dean of the Cathedral of Mainz and Chamberlain to the Courts of Justice, set out from Germany with two companions on 25 April 1483 for a pilgrimage to Jerusalem. Erhard of Reuwich, a painter from Utrecht who accompanied von Breydenbach, made drawings of places and cities seen along the way on which a series of woodcuts, the first image of their kind to appear in a printed book, were based. Amongst the back pages of acquisitions like these, Rosenberger often preserved clippings from news accounts of the auctions at which he had purchased the books. In contrast to the focused scholarly concerns of academics like Buckley and Creel, Rosenberger's collection reflects its organizer's wide-ranging personal interests.

Disciplining Study in Art and Science

The themes of disciplinary study, campus architecture, and display spaces converge in an examination of the study of art history at the University of Chicago at two critical junctures: the construction of the Classics building in 1915, and the planning for a separate Institute of Fine Arts building between 1926 and 1931.

The Classics building was designed to combine the Department of the History of Art with Philosophy, Philology, Greek, and Latin, a grouping testifying to art history's initial dependence on the approaches of classical studies and the modes of inquiry of aesthetic philosophy. Professor Frank Bigelow Tarbell,

FIG. 21

Original handwritten
inventory book for the
F.B. Tarbell Collection
of classical antiquities
(cat. no. 37)

a classical archaeologist, had encouraged President
Harper to establish the Department in 1905, an early
moment in the founding of art history departments
at American universities and colleges. Under
Tarbell's chairmanship, the Department made use
of the nearby Haskell and Walker Museums, as well
as the collection of objects that Tarbell originally
assembled and presented in a large one-room muse-
um on the fourth floor of Classics; it focused on the
culture and artifacts of classical antiquity (cat. nos.
37, 38; figs. 21, 22). As imposing as the museum was
the double height, third-floor reading room in adja-
cent Goodspeed Hall that the History of Art shared
with Classics (cat. nos. 35, 36). Oral testimony
reports that several cases displaying the Tarbell col-
lection were ultimately installed along the south wall
of the room where history and texts dominated the

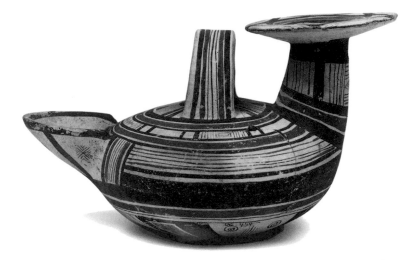

FIG. 22
South Italian
(North Apulia, Daunia),
Ring Askos, early
5th century B.C.E.
(cat. no. 38)

visual analysis of art. This room currently serves as the recital hall for the Music Department.

In 1924, six years after Tarbell's retirement, the Department was revamped under Professor William Sargent, a member of the Department of Education. Sargent changed the name to the Department of Art, signaling a shift in emphasis from the study of art's relation to historical, primarily classical, traditions to the visual analysis of artifacts. The Department of Art expanded in numbers of faculty, students, and courses, taking its cue from the similar transformation of the discipline at Harvard and Princeton. Its dynamism attracted donors for an independent new building that would demonstrate its new disciplinary autonomy. The first was Miss Florence Bartlett, a member of the art-minded Bartlett family that had donated Bartlett Gymnasium for the purpose of "physical culture" at the turn of the century; Max Epstein stepped into her place in 1929. Epstein likened the need for a new "Institute of Fine Arts" to that of the medical clinics he had funded years earlier. In accordance with President Harper's ideal of the combined laboratory, library, and research facility, the new departmental build-

ing was to combine galleries and classrooms for historical study (cat. nos. 34, 39; fig. 23) with studios for design work. Plans developed between 1926 and 1931 generated the crisp perspective drawing by the well-known architect Paul Cret, who had recently completed the Detroit Institute of Arts. The Institute of Fine Arts (cat. no. 33; fig. 24) was to stand on the corner of 58th Street and Woodlawn Avenue, diagonally across from Frank Lloyd Wright's Robie House and directly behind the University's recently completed Rockefeller Chapel (1928), which had been designed by the much-admired modernist architect, Bertram Goodhue. The new Institute was envisioned as adjoining the Oriental Institute, built by Goodhue's successor firm and completed in 1931. Part of a museum complex outside the central quad on terrain of its own, the Institute was also

FIG. 23
American Optical
Corporation (Buffalo,
New York), *Spencer
G.K. Delineascope*
(cat. no. 39a)

located across the street from the women's student center, Ida Noyes Hall, suggesting the gendered aspect of the study of art. However, with changes in the University's priorities under President Robert Maynard Hutchins and a lapse in departmental leadership after Sargent's death, building plans were postponed and Epstein's gift diverted to other purposes. The Department waited until 1974 for a building of its own, including a museum.

Within the quadrangle, notions of art and science were pitted against one another in the struggle experienced by the discipline of sociology as it tried to define its image and its methods. A critical point of contention involved the role that photography should play in sociological research and teaching. Photography had emerged as a powerful tool for reformist work in the hands of activists like Jacob Riis, who claimed to document the conditions of poverty through photography. Those who sought to define sociology as an objective, scientific discipline based on quantitative data eschewed photography, claiming that because photographs could be posed and manipulated, their status as evidence was tainted. Granting that some photographs might qualify as evidence, such as the one of the shanty in

FIG. 24
Paul Cret, *Institute of Fine Arts Building, University of Chicago* (cat. no. 33)

Professor Ernest Burgess's papers (cat. no. 45; fig. 25), they nonetheless preferred to avoid them altogether. Social activists, it was argued, could play upon emotions with their photographs, while scientific sociology would instead develop quantitative analyses, presented in ostensibly objective visual form as charts, graphs, and abstracted diagrams.

The University's Sociology Department, established in the University's inaugural year, was the first American department of sociology to be founded. It led the positivist camp, turning away from the emotionally-charged photographs used in the earliest issues of the campus-based *American Journal of Sociology* (cat. no. 46) to statistical charts that translated social phenomena into numbers or diagram-

FIG. 25
Photographer unknown,
Shanty (cat. no. 45)

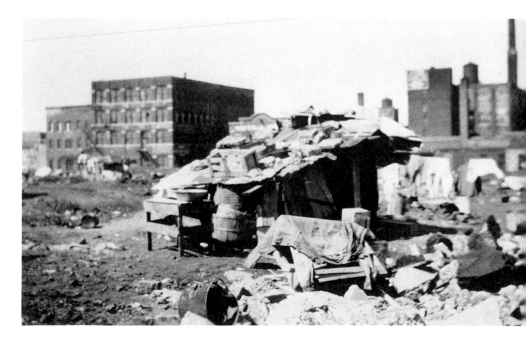

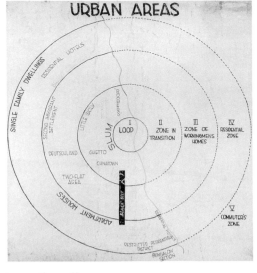

matic renderings (cat. nos. 41, 42). The urban zone map, which abstracted the city of Chicago into concentric zones, was produced by the Sociology Department's Professor Burgess (cat. no. 40; fig. 26). So celebrated is the zone map that it hangs on the Sociology Department's wall as a visual emblem of its influential past.

FIG. 26
Ernest W. Burgess,
Zone Map of Chicago
(cat. no. 40)

Even more permanent is the imagery that faculty chose to represent their discipline in sculptural ornamentation on the façades of the Social Science Research Building (1929). One of the decorative bosses depicts a calculating machine, modeled on the 1928 advertising brochure for the machine that was purchased for the Department's new statistics laboratory (cat. nos. 43, 44; fig. 27). It is impossible to imagine the Department of Art similarly representing itself by its slide projectors (see cat. no. 39; fig. 23); they were magic lanterns and had to remain as inconspicuous as possible.

At the same time, photographers were themselves in the throes of a similar debate as to whether photographs comprised mechanical, documentary representations of the world, or could lay claim to fine art status. Among the latter group of so-called photo-secessionists was Eva Watson-Schütze, wife of a University of Chicago professor of German. This group's friendship with eminent social scientists at the University was the basis for Schütze's soft-focus photographs of John Dewey and his family, exquisite examples of yet another function for the photographic print (cat. nos. 47, 48; fig. 28).

FIG. 27
Social Sciences
Building: Stone Boss
of Calculating Machine,
Repeated on North
and South Façades
(cat. no. 44)

FIG. 28
Eva Watson-Schütze,
Portrait of John Dewey
(cat. no. 47)

Visual Education at the Laboratory Schools

Two years after arriving at the University of Chicago as Professor of Philosophy, Psychology, and Pedagogy, John Dewey founded the University Elementary School in 1896 as a laboratory for his educational ideas. At a time when most classrooms relied on group instruction, drill, recitation, and memorization, Dewey sought to create learning experiences that would link children's activities at school to those of their home and community. With his colleague Colonel Francis Parker, whom he called the "father of progressive education," Dewey stressed the importance of manual training, sensorial development, and nature study (cat. nos. 53–55). The simultaneous acquisition of dexterity and knowledge is displayed in a photograph of children making relief maps in sand trays in order to "experience" geography for a class in 1903 (cat. no. 49; fig. 29).

In lieu of classrooms with forty desks bolted in rows to the floor, children moved about freely, learning reading, writing, and arithmetic only as those skills became necessary to complete activities that interested them. They made frequent field trips in the neighborhood and along the lake shore, spending Monday mornings in 1896–97 at the Field Museum (where the Museum of Science and Industry now stands). The important place that was accorded museum practice in the curriculum is documented by photographs of the children's creation and display of their own collections. These were packaged for circulation and used in class as a sophisticated kind of doll's house (cat. nos. 51, 52;

FIG. 29
Laboratory Schools: Students Making Relief Maps in Sand Trays, 1903 (cat. no. 49)

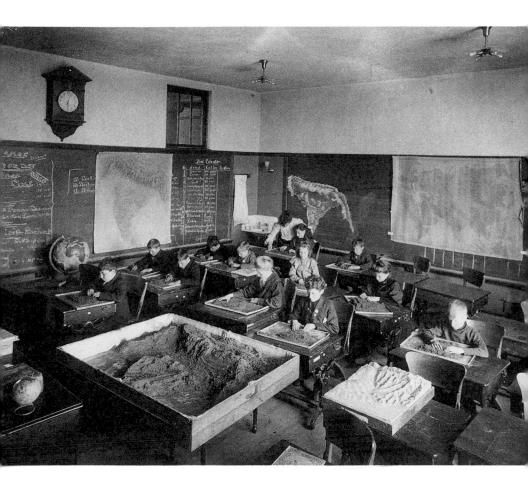

figs. 30, 31). Educators from all over the country descended on the school to observe this phenomenon with their own eyes. So many came that guides were in short supply, leading the Parent-Teachers Association in 1928 to raise money for an introductory lantern-slide show. Thus public interest generated the rich photographic documentation of pedagogies that continue to wax and wane in practice; a small sampling of this visual history formed the basis for an exhibition in celebration of the Laboratory School's centennial year in Regenstein Library's Special Collections (*Education for Life: 100 Years of the Laboratory Schools*, 30 May–14 October 1996).

FIG. 30
*Laboratory Schools:
Traveling Exhibition in
2nd Grade Classroom:
Exterior View*, 1 May
1926 (cat. no. 51)

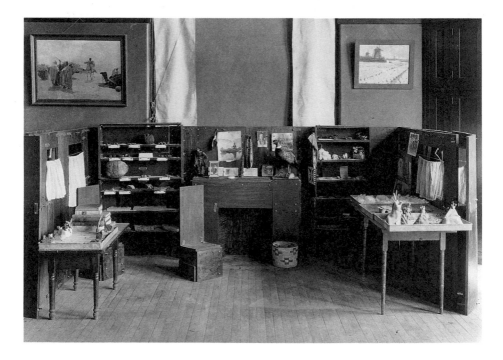

FIG. 31
*Laboratory Schools:
Traveling Exhibition in
2nd Grade Classroom:
Interior View*, 1 May
1926 (cat. no. 52)

Disciplining the Body: Physical Culture and Model Behavior

The University's early commitment to shaping the appearance and social behavior of its student body according to traditional gender norms informed the design of Bartlett Gymnasium, built in 1903, and Ida Noyes Hall, of 1916. Distinct differences between the buildings are indicative of attitudes about the goals of physical culture that have separated men's and women's spaces and programs for much of this century.

Bartlett was planned to accommodate manly sports that would help boys develop into strong, virile men. A stone relief on the north side of the building shows two rams butting heads (cat. no. 60), recalling the words of one of the speeches given on opening day in which men were described as "the noblest of animals" and celebrated for their "tough muscles and steady nerves, vital force and elastic vigor." The entry to the Gym is decorated with an Arthurian mural painted by Frederick Bartlett, a member of the family for whom the building is named. In it, male athletic encounter is presented as medieval tournament, thereby promoting the dual goals of elevated masculine bodily ideals and

FIG. 32
Henry Gilbert, *King Arthur's Knights*, 1911 (cat. no. 59)

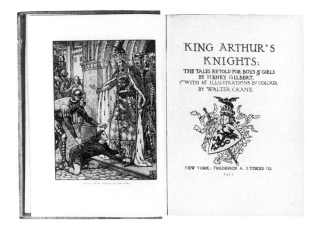

FIG. 33

*Laboratory Schools: Boy
Posing on Desk with
Spear and Shield for
Student Drawing Class,*
1904 (cat. no. 61)

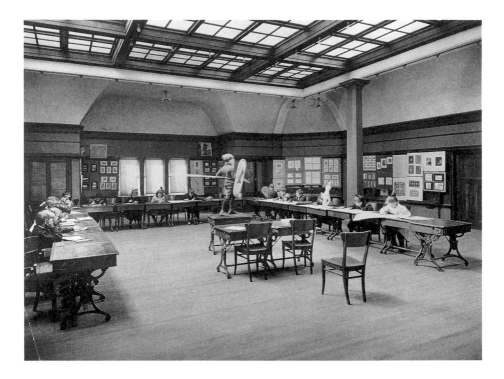

a chivalrous spirit of competition. Contemporary
children's books, such as the Arthurian tales "retold
for boys and girls," deployed similar images to
encourage comparable ends (cat. no. 59; fig. 32).
Young readers were taught through words and pic-
tures—like one of young Owen in the book—"just
what sort of man a perfect knight was"; by inference,
they learned what they could be. The Laboratory
School student who posed for art class with shield
and lance as a model of such behavioral decorum
(cat. no. 61; fig. 33) somehow seems less commit-
ted to that goal than the medieval youth in the fron-
tispiece.

The plan of the first floor of Bartlett Gymnasium reveals the extent to which social interaction in all aspects of physical activity was encouraged (cat. no. 58). The changing area is organized around communal showers, a central drying chamber fitted with marble benches, and a group locker room. The square spaces and rich materials that are specified in the drawing recall the palatial splendor of Diocletian's Baths in ancient Rome (see cat. no. 12; fig. 13). That building, like this one, celebrated and facilitated male socialization through physical culture. Indeed, Amos Alonzo Stagg, Director of Physical Culture, referred to Bartlett as a "palace" in his speech at the opening ceremony.

In contrast to Bartlett, Ida Noyes Hall was built to resemble an English Tudor manor house; elegant interior details instructed women in domestic arts and provided suitable spaces for the cultivation of gracious behavior (cat. no. 62; fig. 34). The base-

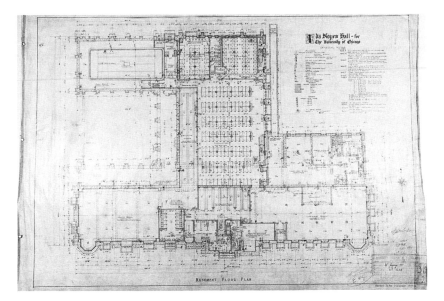

FIG. 34
Shepley Rutan and
Company, *Ida Noyes
Hall for The University
of Chicago: Basement
Floor Plan* (cat. no. 62)

FIG. 35
Ida Noyes Hall: Women Fencers (cat. no. 64)

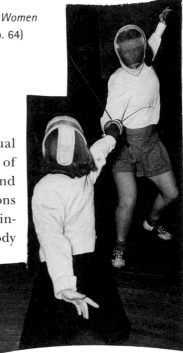

ment plan carefully enumerates individual changing rooms for the encouragement of proper modesty; nearby sewing machines and a Personal Service Department, with provisions for shining shoes and giving manicures, reinforce values of individual and superficial body enhancement. The posed photograph of women fencers likewise celebrated physical beauty and proper posture instead of bodily vigor (cat. no. 64; fig. 35). Seen in hindsight, the photograph of a young girl being weighed in a scale at the Laboratory School, when contrasted to that of her male schoolmate striking a chivalric pose, can also be construed as attending to gendered issues of bodily image (cat. no. 63).

Molding the College Student: Art to Live With

University alumnus Joseph R. Shapiro introduced his Art to Live With Collection (see cat. no. 65) to the University in 1958 in order to "acquaint students with the experience of having an original work of art to live with." Students were invited to take works into dormitory rooms, carrying the borrowing principle and privilege from the library into the realm of museum-quality works of art (cat. nos. 66–68; figs. 36, 37). *The Chicago Maroon* (8 April 1960) explained that the collection maintained "a level of quality so that the art work will have an effect on students' lives." Not only did this program reinforce the intro-

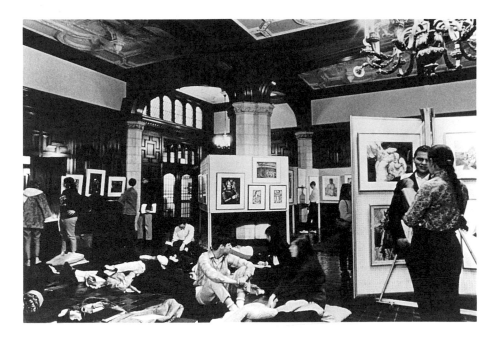

FIG. 36

Ida Noyes Hall: Students Waiting to Select Works Amid Temporary Panels Displaying Art to Live With *Collection* (cat. no. 66)

duction to art that students absorbed in the core course program, but it extended that message from the rarified classroom and museum into daily life.

This idea was born in conversation between Shapiro and Harold Haydon, who was not only a member of the Art Department but also an artist and Dean of Students in the College. The Art Department deliberately did not administer the program. Shapiro wanted all students, whether or not they considered themselves "art people," to have the unique experience of living with a work of art. To this end, this program was run by the Student Activities Office. Every quarter the collection was exhibited anew at Ida Noyes Hall, where students queued for a number to claim their choice of print,

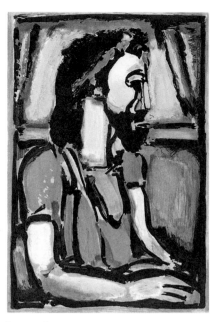

FIG. 37
Georges Rouault
(French, 1871–1958),
Christ (in Profile), 1936
(cat. no. 68)

drawing, or watercolor. By the 1960s students were sleeping out overnight to obtain the best places in line. The only cost was an insurance fee, which rose from fifty cents to a peak of five dollars in the last years of the program. The rising value and fragility of the works caused the program's suspension in the early 1990s; the Smart Museum is now working to revive it. Seeded with works by artists as celebrated as Goya, Picasso, and Rouault, the collection was originally composed largely of works by young Chicago artists, including Leon Golub, Ellen Lanyon, and June Leaf, who have since become prominent in their own right.

Joel Snyder, Professor and Chair of the Art History Department, recently described (at The First Joseph R. Shapiro Award Dinner benefiting the Smart Museum, 11 October 1995) the program's impact on his life as an undergraduate:

> We carefully chose our prints—I took an extraordinary piece by Miró—and we hung them in our cells and returned to them nightly. I recall staring at the picture intently as I wrote my papers—it became a muse for me—but I also learned about it from living with it. . . . The print anchored my education as it did for the others who were given the rare privilege of living with Joe Shapiro's art. We talked about our prints, exchanged them from time to time, and each of us was touched somehow by the experience of sleeping and eating and studying and joking around in a room graced by something extraor-

dinary that hung on the wall. . . . We learned about the complexity of art . . . and we learned something about being responsible citizens in a world that was to become increasingly willing to trust us. . . . And each of us remembers the exact pieces we had.

Constructing a Public Image: The University of Chicago and the World's Fair

While University programs in physical and visual culture have shaped the look and looking of enrolled students, University publicity has sought to identify the institution with the expertise expected to remake everyday life in the world at large. The University's contribution to the 1933 Century of Progress exposition in Chicago specifically constructed the image of the University in terms of *visual* expertise, employing the celebrated telescope at its Yerkes Observatory to harness the light of a far-off star to illuminate the main exhibit at the fair.

A spiraling orb featured in publicity and depicted on countless souvenirs sold to visitors (cat. nos. 76, 77; fig. 38), the star Arcturus represented the aspirations of the city of Chicago in hosting the Century of Progress exposition. The name and theme of the fair made reference to the city's own spectacular growth over a mere hundred years since its foundation. Arcturus served as a visual sign of the technological achievements of those decades and the fair organizers' undiminished expectations for the future. During the depths of the Depression, the souvenir items

FIG. 38
Century of Progress pennant, featuring University of Chicago and Arcturus logos (cat. no. 77)

bearing its image served as symbols of hope for innovation and the prospect of improvement in the decades ahead.

The University conceived this contribution with a similar intention to the city's to advertise its central position as a leader in the progressive mastery of space and time. From the outset, the University was keen to participate in the fair, as a letter from James Stifler of the University's Committee on Development to the President of the Organizing Committee makes clear (cat. no. 69). Scientists from the University's Yerkes Observatory helped to organize the Hall of Science, the most popular exhibit at the fair. They originated the idea of using their telescope to harness light that had been emitted by the distant star Arcturus forty years earlier, in the year of Chicago's famous World's Columbian Exposition and the simultaneous founding of the University of Chicago next door to its grounds. This "feeble beam" provided illumination of the science pavilion for the opening of the 1933 fair, an event that was well covered by the press and garnered instant acclaim for the University (cat. nos. 73, 75). Although the Observatory stands in Wisconsin, the University had long presented that facility as part of its enterprise at expositions, beginning with its display of the telescope itself at the 1893 Columbian Exposition and again in the model of its newly-built campus exhibited at the 1904 Saint Louis Exposition, in which the Observatory was presented as an appendage to the main quadrangle, across the Midway Plaisance (cat. no. 74). Its use of the telescope in 1933 enabled the University to manage

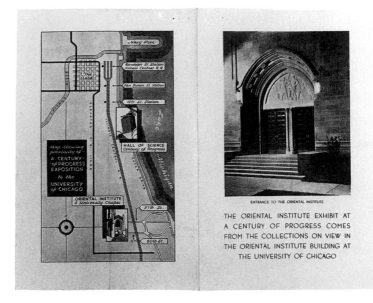

ENTRANCE TO THE ORIENTAL INSTITUTE

THE ORIENTAL INSTITUTE EXHIBIT AT
A CENTURY OF PROGRESS COMES
FROM THE COLLECTIONS ON VIEW IN
THE ORIENTAL INSTITUTE BUILDING AT
THE UNIVERSITY OF CHICAGO

FIG. 39
Invitation/advertisement
for the Oriental Institute
exhibition during the
Century of Progress
exposition (cat. no. 71)

not only space but also time, bringing its own foundation date into the narrative of the Century of Progress.

The University also pointed to its mastery of time in another way, by linking its contribution to the Hall of Science at the fairgrounds, just south of the center of the city, to its new Art Deco-style museum building for the Oriental Institute on the University campus, twenty blocks to the south of the fair. The Oriental Institute became the historical counterpart to the futuristic Hall of Science, the base for pioneering research on ancient Egypt; the two sites were jointly featured in a pamphlet urging fair-goers to visit the University campus as well, with a map emphasizing their proximity on Chicago's South Side (cat. no. 71; fig. 39). A poster specially commissioned to advertise the Oriental Institute's collections and the University's campus activities to fair-goers was an instant success and remains on sale at the museum today (cat. nos. 70, 72; fig. 40). Thus lured to the threshold of the Oriental Institute, visitors encountered another representation of scholarly enlightenment in the relief above the entrance depicting the encounter of modern archaeologist

with ancient Egyptian under the light of the sun disk rather than Arcturus, and illustrating the use of the archaeologist's counterpart to the astronomer's telescope, the magnifying glass.

For its clever contribution of the emblem for the fair, an image that also brought the University instant visibility among the fair's many visitors, the University was awarded an elegantly inscribed diploma (cat. no. 78; fig. 41). The publicity enterprise converted highly sophisticated visual technologies

to equally acute marketing devices. Yet it also literalized the notion of scholarly enlightenment in its imagery of light and viewing techniques, and thereby reveals with special poignancy the visual aspect of pedagogical history across the disciplines at a University that has so often presented itself as platonically iconoclastic.

FIG. 41
Diploma for Exceptional Photographic Art, Awarded to Yerkes Observatory of The University of Chicago, Century of Progress, 1933 (cat. no. 78)

A Guide to "Looking to Learn" Sites

The exhibition was designed to give an overview of the ways in which the visual, and particularly the visual as it relates to the varied collections the University, has amassed over time, has intersected with pedagogical practice at the University. This walking tour returns you to the original contexts of the objects on display in the exhibition and discussed in the catalogue.

1.

The David and Alfred Smart Museum of Art, 5550 South Greenwood Avenue. Opened in 1974 together with the Department of Art History in the Cochrane-Woods Art Center complex, the Smart Museum houses the University's fine arts collection, which incorporates several earlier departmental and faculty collections, including the F.B. Tarbell and Stanley McCormick Collections of classical antiquities, bronze-age Chinese antiquities collected by Professor Herrlee G. Creel, and Old Master and nineteenth-century prints from the Max Epstein Archive.
T, W, F 10:00 am–4:00 pm, Th 10:00 am–9:00 pm, Sa–Su noon–6:00 pm

2.

Bartlett Gymnasium, 5640 South University Avenue. Bartlett Gym was designed to convey the importance of "manly sports" to students. The Bartlett mural, on the wall facing the main doors, depicts medieval athletic tournaments. The shield over the mural shows Vires offering assistance to Scientia and Litterae, thus providing a visual lesson in the principle of "healthy body, healthy mind." Also note the stained glass window over the main door with scenes from Sir Walter Scott's *Ivanhoe.*
M–F 9:00 am–11:30 pm, Sa 10:00 am–7:30 pm, Su noon–7:30 pm

3.

Joseph Regenstein Library, Special Collections, 1100 East 57th Street. Special Collections houses the *Speculum Romanae Magnificentiae* print series, part of the Berlin Collection, and the Ludwig Rosenberger Library of Judaica, both major colections acquired by the University for pedagogical use.
M–F 8:30 am–4:30 pm, Sa 8:30 am–1:00 pm

4.

Classics Building and Goodspeed Hall, 1010 East 59th Street. The Classics Building was the original home of the History of Art Department and had a museum on its fourth floor for the collection of classical antiquities. This museum emphasized the informational qualities of its artifacts over the aesthetic. The carvings of classical figures on the outside of the building informed the viewer that weighty pedagogy was taking place inside. The third

floor recital hall in Goodspeed Hall was originally the Classics library, which included the art history reading room. The original woodwork remains.
M–F 9:00 am–5:00 pm

5.
Haskell Hall, 5836 South Greenwood Avenue. Originally the Haskell Oriental Museum, this building retains only a few cases and a large totem pole displayed in the first floor stairwell that refer back to this building's original role. It now houses the Department of Anthropology. The roof of the building is less ornate than others because it once had skylights for the galleries within.
M–F 9:00 am–5:00 pm

6.
Social Science Research Building, 1126 East 59th Street. The Social Science Building is decorated with symbols appropriate to the academic work taking place within. On the 59th Street side of the building reliefs of the (pre-computer) tools of the social sciences can be seen, including a statistics adding machine and compass.
M–F 9:00 am–5:00 pm

7.
Walker Museum, 1115 East 58th Street. The Walker Museum was one of the University's first museum buildings. It housed the paleontology collection, now at the Field Museum.

The building has been extensively renovated for the Graduate School of Business, and the only trace of its previous role is the name "Walker Museum" over the front door.
M–F 9:00 am–5:00 pm

8.
The Oriental Institute Museum, 1155 East 58th Street. The Oriental Institute Museum was built in 1931 to house the Near Eastern collections formerly in the Haskell Museum. The painted and carved decoration of the museum's lobby and galleries is a combination of ancient Near Eastern, Egyptian, and "art moderne" motifs. The stone tympanum relief over the main entrance on 58th Street depicts the "transit of civilization from the ancient Orient to the West."
Tu–Sa 10:00 am–4:00 pm, Su noon–4:00 pm

9.
Original "Institute of Fine Arts" site, southwest corner of South Woodlawn Avenue and East 58th Street. In the late 1920s, a fine arts center was planned for this site, reflecting the new prominence of art as a discipline in its own right. The building was to have adjoined both Rockefeller Chapel and the Oriental Institute. The fine arts building was never built, and its successor, the Cochrane-Woods Arts Center, constructed in 1973–74, was on the fringe of campus, rather than at its heart.

10.
Ida Noyes Hall, 1212 East 59th Street. Originally constructed as a student center and gymnasium for female students (Bartlett Gymnasium was exclusively male), Ida Noyes Hall presents a very different image of physical culture and women's relationship to it than the mural and window in Bartlett. Worth noting are the mural in the third floor theater and the exterior decorations which depict women engaging in "appropriate" activities.
M–F 8:30 am–midnight, Sa 10:00 am–midnight, Su 1:00 pm–10:00 pm

11.
University Laboratory Schools (Emmons Blaine Hall and Charles Hubbard Judd Hall), 1362 East 59th Street and 5835 South Kimbark Avenue, respectively. The Laboratory Schools were founded as a means of putting educational theory into practice. The close relationship between the Schools and the Department of Education is manifested physically by links between the Schools's Blaine Hall and the Department's Judd Hall. Although the Lab School buildings are not open to the public, there are occasional exhibitions in Judd Hall.

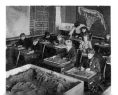

Checklist

The checklist is arranged according to the thematic divisions of the exhibition and catalogue essay. Dimensions are in inches followed by centimeters in parentheses; unless otherwise indicated, height precedes width precedes depth.

Museum or Library: Campus Display Spaces and Disciplinary Definitions

1

General Campus View of Henry Ives Cobb Plan of 1893
Gelatin silver print (vintage impression) on board, board: 5 ¼ x 8 ½ (13.3 x 21.6)
Lent by Special Collections,
The University of Chicago Library,
Archival Photofiles, Series II

2

Recent aerial view of the campus of the University of Chicago
Gelatin silver print (new impression), sheet: 8 x 10 (20.3 x 25.4)
Courtesy of The University of Chicago, Office of News and Information

3

Handwritten notes for President Harper's statement at the cornerstone ceremony of Haskell Oriental Museum, 1893
Ink on paper, three sheets, each: 8 ½ x 5 ½ (21.6 x 14)
Lent by Special Collections,
The University of Chicago Library,
Presidents' Papers, 1889–1925

4

Haskell Oriental Museum: Exhibition Gallery, 1898
Gelatin silver print (new impression), sheet: 8 x 10 (20.3 x 25.4)
Courtesy of Special Collections,
The University of Chicago Library

5

Carbon copy of typewritten proposal to Board of Libraries, Laboratories and Museums, 5 April 1904
Carbon ink on paper, sheet: 11 x 8 ½ (27.9 x 21.6)
Lent by Special Collections,
The University of Chicago Library,
Presidents' Papers, 1889–1925

6

Walker Museum: Exhibition Gallery
Gelatin silver print (vintage impression) on board, board: 9 ⅛ x 7 ³⁄₁₆ (23.2 x 18.3)
Lent by Special Collections,
The University of Chicago Library,
Archival Photofiles, Series II

7

Edward Larrabee Barnes
Proposal for Arts Center at 55th Street and Greenwood Avenue, 1972
Gouache on paperboard, sight: 30 x 39 (76.2 x 99.1)
Courtesy of The University of Chicago Office of Facilities Planning and Management

8

Smart Museum Public Relations Scrapbook (no. 1), opened to the page with a sample of the Museum's dedication invitation and a photograph of the ribbon cutting ceremony, October 1974
The David and Alfred Smart Museum of Art, The University of Chicago

9a–b
Color in Art, 1975
[a] Commercially printed poster for the
Smart Museum exhibition, ink on wove
paper, sheet: 16 x 11 (40.6 x 27.9); [b]
installation photograph of the Smart
Museum exhibition, gelatin silver print,
sheet: 8 x 10 (20.3 x 25.4)
The David and Alfred Smart Museum of
Art, The University of Chicago

Institutional, Disciplinary, and Private Collecting

10
A Valuable Library Bought
Microfilm reproduction from the
front page of the *New York Times*,
28 October 1891
Courtesy of The University of Chicago,
Joseph Regenstein Library

11
Italian
Trajan's Column
From the series *Speculum Romanae
Magnificentiae* (Rome: Antonio
Salamanca, 1541–62)
Engraving, plate: 18 ½ x 13 (47 x 33)
Lent by Special Collections,
The University of Chicago Library,
Berlin Collection

12
Italian, after Ambrogio Brambilla
*Thermae Diocletianae et Maximianae inter
Quirinalem et Viminalem*
From the series *Speculum Romanae
Magnificentiae* (Rome: Claudio Brambilla,
1582)
Engraving, plate: 11 ⅞ x 20 ¾ (30.2 x 52.7)
Lent by Special Collections,
The University of Chicago Library,
Berlin Collection

13
Italian
*Vestigii delle Terme di Diocletiano dalla parte
di dentro che guarda verso scirocco*
From the series *Speculum Romanae
Magnificentiae* (Rome: Goert van Schaych,
1621)
Engraving, plate: 8 ¼ x 14 ¾ (21 x 37.5)
Lent by Special Collections,
The University of Chicago Library,
Berlin Collection

14
Italian, possibly after Ononfrio Panvinio
*Circi Maximi et antiqui imperatorum
Romanorum palatii ichnographia*
From the series *Speculum Romanae
Magnificentiae* (probably Dutch edition of
Panvinio, *De ludis circensibus*)
Engraving, plate: 13 ¼ x 17 ⅜
(33.7 x 44.1)
Lent by Special Collections,
The University of Chicago Library,
Berlin Collection

15

Designer and carver unknown
Foliate Capital, early 20th century
Carved stone, h.: 5 ½ (14)
The foliate capital originally supported a
bust of an ancient philosopher, one of a
series which decorated the old Classics
Library in Goodspeed Hall.
The David and Alfred Smart Museum of
Art, The University of Chicago

16

Chinese, Shang dynasty
Knife, 13th–12th century B.C.E.
Cast bronze, l.: 13 ⅞ (35.3)
The David and Alfred Smart Museum of
Art, The University of Chicago, Gift of
Prof. and Mrs. Herrlee G. Creel
1986.341

17a–b

Chinese, Shang dynasty
Two Bird-finial Hairpins, 13th–12th
century B.C.E.
Carved bone, [a] l.: 5 ⅟₁₆ (12.4);
[b] 3 ½ (8.9)
The David and Alfred Smart Museum of
Art, The University of Chicago, Gift of
Prof. and Mrs. Herrlee G. Creel
1986.357 and 1986.358

18

Chinese, late Shang dynasty, Chu group
of diviners
Oracle Bone, circa 12th–11th century B.C.E.
Incised bone, l.: 3 ⅟₁₆ (7.8)
Inscribed: Wu ought not
The David and Alfred Smart Museum of
Art, The University of Chicago, Gift of
Prof. and Mrs. Herrlee G. Creel
1986.393

19

Joseph Jacobson and Erwin Jospe
Hawa Naschira! Auf Lasst uns singen!, 1935
Commercially printed songbook, cover:
11 ¼ x 8 ¼ (28.6 x 21)
Lent by Special Collections, The
University of Chicago Library, The
Ludwig Rosenberger Library of Judaica

20

F. Bonaventura
*Statutes Regulating the Jewish Community of
Ferrara*, 1761
Woodcut, bi-fold sheet, opened:
11 x 15 ⅞ (27.9 x 40.3)
Lent by Special Collections, The
University of Chicago Library, The
Ludwig Rosenberger Library of Judaica

21

The Turf Frauds, Harry Benson
From *Vanity Fair*, 29 September 1877
Lithograph, two sheets, illustration sheet:
15 ⅟₁₆ x 10 ⅜ (38.2 x 26.4), text sheet:
15 ¼ x 10 ⅜ (38.7 x 26.4)
Lent by Special Collections, The
University of Chicago Library, The
Ludwig Rosenberger Library of Judaica

22

Karl Marx
*Plate 17: Translations of Marx Throughout
the World*
From *Leben und Werk*, 1953
Commercially printed book with loose
folios, sheet: 16 ⅞ x 24 (42.9 x 61)
Lent by Special Collections, The
University of Chicago Library, The
Ludwig Rosenberger Library of Judaica

23

*Circular Regarding Collections of Religious
Objects*, 1894
Xerox reproduction of printed brochure
(Chicago: University of Chicago, 1894),
pp. 1, 14–15
The David and Alfred Smart Museum of
Art, The University of Chicago

24

Original handwritten inventory book of
the Haskell Oriental Museum for the
Buckley Collection
Ink on paper in commercial notebook,
sheet: 6 ¾ x 4 (17.2 x 10.2)
The David and Alfred Smart Museum of
Art, The University of Chicago

25
Japanese, Meiji period
Votive Plaque, 1886
Ink and opaque pigment on wood,
15 ½ x 12 ½ (39.5 x 32)
The David and Alfred Smart Museum of
Art, The University of Chicago,
Edmund Buckley Collection
TR 849/421

26
Japanese, Meiji period
Votive Plaque, 1892
Opaque pigment on wood and paper,
13 x 8 ½ (33 x 22)
The David and Alfred Smart Museum of
Art, The University of Chicago,
Edmund Buckley Collection
TR 849/422

27a–d
Photographers unknown
Japanese, Meiji period
*Phallic Stones and Straw Phallus Fertility
Symbols at Shrine Sites in Japan*, late 19th
century
Four albumen [a, b] and gelatin silver [c,
d] prints (all vintage impressions),
sheets: [a] 4 ³⁄₁₆ x 5 ¾ (10.6 x 14.6);
[b] 3 ¹⁵⁄₁₆ x 5 ⁷⁄₁₆ (10 x 13.8);
[c] 3 ¹³⁄₁₆ x 2 ¹³⁄₁₆ (9.7 x 7.1);
[d] 5 ¹⁄₁₆ x 3 ½ (13.2 x 8.9)
The David and Alfred Smart Museum of
Art, The University of Chicago,
Edmund Buckley Collection
TR 849/uncatalogued

28a–c
Japanese, Edo or Meiji period
Three Wooden Phallic Objects,
18th or 19th century
Carved wood with decoration in ink and
paint, [a] h.: 7 (17.8); [b] h.: 7 ½ (19);
[c] h.: 8 ¾ (21.4)
The David and Alfred Smart Museum of
Art, The University of Chicago,
Edmund Buckley Collection
TR 849/201, 202, and 203

29a–c
Japanese, Edo or Meiji period
Three Phallic Stones, 18th or 19th century
Natural stones, [a] l.: 4 (10); [b] l.: 3
(7.6); [c] 2 ½ x 3 (6.4 x 7.6)
The David and Alfred Smart Museum of
Art, The University of Chicago,
Edmund Buckley Collection
TR 849/195, 196, and 388

30a–b
Japanese, Edo or Meiji period
Two Divination Bones, 18th or
19th century
Animal shoulder blades,
[a] l.: 5 ½ (13.4); [b] l.: 4 ½ (11.6)
The David and Alfred Smart Museum
of Art, The University of Chicago,
Edmund Buckley Collection
TR 849/149 and 390

31
Photographer unknown
Japanese, Meiji period
Shinto Ceramic Ritual Vessels,
late 19th century
Albumen print (vintage impression)
mounted on board, sheet:
2 ⅜ x 3 ¾ (6 x 9.5)
The David and Alfred Smart Museum
of Art, The University of Chicago,
Edmund Buckley Collection
TR 849/uncatalogued

32a–m
Japanese, Meiji period
Thirteen Shinto Ceramic Ritual Vessels,
19th century
Glazed earthenware, various dimensions
The David and Alfred Smart Museum
of Art, The University of Chicago,
Edmund Buckley Collection
TR 849/76, 77, 79, 80, 83, 84–85, 87, 89,
95–96, 403, and 408

Disciplining Study in Art and Science

33
Paul Cret
Institute of Fine Arts Building,
University of Chicago
Pencil on paper, sight:
16 x 27 ½ (40.6 x 69.9)
Lent by Special Collections,
The University of Chicago Library,
Architectural Drawings Collection

34
Two Preliminary Studies of the Proposed Fine
Arts Building, North of Rockefeller Chapel
Two glass lantern slides, each:
4 x 5 (10.2 x 12.7)
Lent by the Department of Art Slide
Collection, University of Chicago
(A18 US 2596 and A18 US 2597)

35
Shepley, Rutan & Coolidge
Fourth Floor Plan: Classics Building for
The University of Chicago
Pen and ink on paper, sheet:
18 x 28 ³⁄₁₆ (45.7 x 71.6)
Lent by Special Collections,
The University of Chicago Library,
Architectural Drawings Collection

36
Classics Building: Interior of Library
Gelatin silver print (vintage impression)
on board, board: 7 x 10 ⅜ (17.8 x 26.4)
Lent by Special Collections,
The University of Chicago Library,
Archival Photofiles, Series II

37
Original handwritten inventory book for
the F.B. Tarbell Collection of classical
antiquities
Ink on paper in commercial notebook,
sheet: 10 ⅜ x 7 ¾ (26.4 x 19.7)
The David and Alfred Smart Museum of
Art, The University of Chicago

38
South Italian, North Apulia, Daunia
Ring Askos, early 5th century B.C.E.
Earthenware with slip-painted
decoration, h.: 4 ¹¹⁄₁₆ (11.9), diam. of
body: 5 ⅛ (13.1)
The David and Alfred Smart Museum
of Art, The University of Chicago,
The F.B. Tarbell Collection, Gift of
E.P. Warren, 1902
1967.115.454

39a–b
American Optical Corporation,
Buffalo, New York
Spencer G.K. Delineascope
[a] Lantern slide projector, h.: 9 ⅝
(24.5), l.(compressed): 23 (58.4); [b]
manufacturer's commercially printed
operating manual
Lent by the Department of Art Slide
Collection, The University of Chicago

40
Ernest W. Burgess
Zone Map of Chicago
Ink and color on paper, sight: 38 ¼ x 36
(97.2 x 91.4)
Courtesy of the Department of Sociology,
The University of Chicago

41
Ernest W. Burgess
Crime and Deportation: Chart of Immigration
and Deportation, circa 1928
Typewritten manuscript, sheet: 11 x 8 ½
(27.9 x 21.6)
Lent by Special Collections,
The University of Chicago Library,
Ernest W. Burgess Papers

42
Ernest W. Burgess
Crime and Deportation: Chart of Immigration
and Deportation, circa 1928
Pen and ink on graph paper, sheet:
9 ¼ x 9 ⅜ (23.5 x 23.9)
Lent by Special Collections,
The University of Chicago Library,
Ernest W. Burgess Papers

43
Marchant Calculating Machine Company,
Oakland, California
Advertisement for a Calculator, circa 1928
Commercially printed offset lithograph,
sheet: 12 ¼ x 18 (31.1 x 45.7)
Lent by Special Collections,
The University of Chicago Library,
William Fielding Ogburn Papers

44
*Social Sciences Building: Stone Boss of
Calculating Machine, Repeated on North
and South Façades*
Gelatin silver print (new impression),
image: 3 x 3 (7.6 x 7.6)
Courtesy of Special Collections,
The University of Chicago Library

45
Photographer unknown
Shanty
Gelatin silver print (vintage impression),
sheet: 2 ¾ x 4 ½ (7 x 11.4)
Lent by Special Collections,
The University of Chicago Library,
Ernest W. Burgess Papers

46
A Pauper
Photograph reproduced in John R.
Commons, "The Junior Republic,"
American Journal of Sociology 3
(November 1897): 288
Lent by The University of Chicago,
Joseph Regenstein Library

47
Eva Watson-Schütze
Portrait of John Dewey
Platinum print (vintage impression),
sheet: 8 x 6 ¼ (20.3 x 15.9)
Lent by Special Collections,
The University of Chicago Library,
Eva Watson-Schütze Photographs

48
Eva Watson-Schütze
Portrait of Alice, Jane, and Gordon Dewey
Platinum print (vintage impression),
sheet: 7 ⅝ x 5 ⅞ (19.4 x 14.9)
Lent by Special Collections,
The University of Chicago Library,
Eva Watson-Schütze Photographs

Visual Education at the Laboratory Schools

49
*Laboratory Schools: Students Making Relief
Maps in Sand Trays*, 1903
Gelatin silver print (vintage impression)
on board, board: 7 ¾ x 9 ¾ (19.7 x 24.8)
Lent by Special Collections,
The University of Chicago Library,
Laboratory Schools Records

50
Laboratory Schools: Natural History Museum,
1904–5
Gelatin silver print (vintage impression)
on board, board: 7 ¾ x 9 ¾ (19.7 x 24.8)
Lent by Special Collections,
The University of Chicago Library,
Laboratory Schools Records

51
*Laboratory Schools: Traveling Exhibition in
2nd Grade Classroom: Exterior View*,
1 May 1926
Gelatin silver print (vintage impression),
sheet: 7 ⅞ x 9 ⅞ (20 x 25.1)
Lent by Special Collections,
The University of Chicago Library,
Laboratory Schools Records

52
*Laboratory Schools: Traveling Exhibition in
2nd Grade Classroom: Interior View*,
1 May 1926
Gelatin silver print (vintage impression),
sheet: 7 ⅞ x 10 ⅛ (20 x 25.7)
Lent by Special Collections,
The University of Chicago Library,
Laboratory Schools Records

53
Laboratory Schools: Memorandum on
Industrial Art in Lower Grade Schools,
4 March 1918
Typewritten manuscript, sheet:
19 ¾ x 8 ¼ (27.3 x 21)
Lent by Special Collections,
The University of Chicago Library,
Laboratory Schools Records

54

Laboratory Schools: Toys Prepared for South Community Center Settlement House, 1928
Gelatin silver print (vintage impression),
sheet: 7 ⅞ x 9 ⅞ (20 x 25.1)
Lent by Special Collections,
The University of Chicago Library,
Laboratory Schools Records

55

Laboratory Schools: Boys and Girls Working in the Wood Shop, circa 1904–5
Gelatin silver print (new impression),
8 x 10 (20.3 x 25.4)
Courtesy of The University of Chicago,
Laboratory Schools Records

56

Alex Kirshner, student fabricator
Pig-shaped Cutting Board, 1987–88
Wood, l.: 11 (27.9)
Lent by Catharine D. Bell

57

Ben Field, student fabricator
Leonard K.W. Wisnewski, teacher
Step Stool, circa 1984
Wood, h.: 9 (22.9), l. 18 (45.7)
Lent by Ben Field

Disciplining the Body: Physical Culture and Model Behavior

58

Shepley, Rutan & Coolidge
The Gymnasium for The University of Chicago: First Story Plan
Pen and ink on paper, sheet:
25 ⅛ x 37 (63.8 x 94)
Lent by Special Collections,
The University of Chicago Library,
Architectural Drawings Collection

59

Henry Gilbert
King Arthur's Knights
Commercially printed book (New York:
Frederick A. Stokes, 1911), cover:
9 ⅜ x 6 ½ (23.9 x 16.5)
Lent by Special Collections,
The University of Chicago Library,
Encyclopedia Britannica Collection of
Books for Children

60

Bartlett Gymnasium: Exterior Stone Ornament of Butting Rams
Gelatin silver print (vintage impression),
sheet: 10 ⅞ x 14 (27.6 x 35.6)
Lent by Special Collections,
The University of Chicago Library,
Archival Photofiles, Series II

61

Laboratory Schools: Boy Posing on Desk with Spear and Shield for Student Drawing Class, 1904
Gelatin silver print (vintage impression)
on board, image: 6 ⅞ x 9 (17.5 x 22.9)
Lent by Special Collections,
The University of Chicago Library,
Laboratory Schools Records

62

Shepley Rutan and Company
Ida Noyes Hall for The University of Chicago: Basement Floor Plan
Pen and ink on paper, sheet:
30 x 42 (76.2 x 106.7)
Lent by Special Collections,
The University of Chicago Library,
Architectural Drawings Collection

63

Laboratory Schools: Girl Being Weighed in a Scale
Gelatin silver print (new impression),
sheet: 10 x 8 (25.4 x 20.3)
Courtesy of The University of Chicago,
Laboratory Schools

64

Ida Noyes Hall: Women Fencers
Gelatin silver print (vintage impression),
irr. sheet, max. dim.:
11 ½ x 6 ⅞ (29.2 x 17.5)
Lent by Special Collections,
The University of Chicago Library,
Archival Photofiles, Series IV

Molding the College Student: Art to Live With

65
Joseph R. Shapiro Art to Live With *Poster*
Computer-printed advertisement on
paper, sheet: 11 x 8 ½ (27.9 x 21.6)
Lent by Special Collections,
The University of Chicago Library,
Archival Reference Collection

66
Ida Noyes Hall: Students Waiting to Select Works Amid Temporary Panels Displaying Art to Live With *Collection*
Gelatin silver print (vintage impression),
sheet: 11 x 14 (27.9 x 35.6)
Lent by Special Collections,
The University of Chicago Library,
Archival Photofiles, Series IV

67
University of Chicago students examining
prints and drawings during the selection
of works for loan from the *Art to Live
With* collection
Photograph reproduced in the *University
Alumni Magazine* (March 1959): 8–9
Lent by Special Collections,
The University of Chicago Library,
Archival Reference Collection

68
Georges Rouault
French, 1871–1958
Christ (in Profile), 1936
From the *Passion* series
Color etching and aquatint, plate:
12 $\frac{13}{16}$ x 8 $\frac{9}{16}$ (32.5 x 21.8)
The David and Alfred Smart Museum of
Art, The University of Chicago,
Joseph R. Shapiro Art to Live With
Collection
TR 1180/90

Constructing a Public Image: The University of Chicago and the World's Fair

69
Letter from James Stifler (University of
Chicago Committee on Development) to
Rufus Dawes (president of Century of
Progress Exposition), 7 July 1933
Carbon copy of typewritten manuscript,
sheet: 11 x 8 ½ (27.9 x 21.6)
Lent by Special Collections,
The University of Chicago Library,
Presidents' Papers, 1925–1945

70
William P. Welsh
*Oriental Institute Poster for the Century of
Progress*, 1933
Commercially printed offset lithograph,
sheet: 37 x 23 (94 x 58.4)
Lent by the Oriental Institute Museum,
University of Chicago

71
Invitation/advertisement for the Oriental
Institute exhibition during the Century
of Progress exposition
Commercially printed folded card, sheet
(folded): 8 ½ x 5 ½ (21.6 x 14)
Lent by Special Collections,
The University of Chicago Library,
Presidents' Papers, 1925–1945

72
Clipping of advertisement to attract
Century of Progress exposition visitors to
the University of Chicago, featuring
Oriental Institute poster [see cat. no. 70]
Newsprint, from *Chicago Daily News*,
26 August 1933
Lent by Special Collections,
The University of Chicago Library,
Presidents' Papers, 1925–1945

73
Century of Progress
Newsprint brochure, sheet (unfolded):
15 ¾ x 23 ½ (40 x 59.7)
Lent by Special Collections,
The University of Chicago Library,
Presidents' Papers, 1925–1945

74
Campus Model, St. Louis World's Fair, 1904
Gelatin silver print (vintage impression)
on board, board: 6 ⅞ x 8 ⅞ (17.5 x 22.5)
Lent by Special Collections,
The University of Chicago Library,
Archival Photofiles, Series II

75
*Trap Beam from Star Arcturus at Yerkes
Observatory to Open 1933 World's Fair
on May 27*
Newsprint, clipping from the *Daily
Maroon*, 12 May 1933, p. 4
Lent by Yerkes Observatory Archives

76
Century of Progress bookmark, featuring
University of Chicago and Arcturus logos
Stamped brass. l.: 4 ½ (11.4)
Lent by Michael Field, College '53

77
Century of Progress pennant, featuring
University of Chicago and Arcturus logos
Ink on felt. l.: 22 ¾ (57.8)
Lent by Linda Seidel

78
*Diploma for Exceptional Photographic Art,
Awarded to Yerkes Observatory of
The University of Chicago, Century of
Progress*, 1933
Commercially printed, ink on paper,
sheet: 12 x 9 (30.5 x 22.9)
Lent by Yerkes Observatory Archives